WHAT BOOKS PRESS

AN IMPRINT OF

THE GLASS TABLE

COLLECTIVE

LOS ANGELES

ALSO BY PAUL LIEBER

Interrupted by the Sea
Chemical Tendencies

SLOW RETURN

SLOW RETURN

PAUL LIEBER

WHAT BOOKS PRESS

LOS ANGELES

Library of Congress Cataloging-in-Publication Data

Names: Lieber, Paul, author.
Title: Slow return / Paul Lieber.
Other titles: Slow return (Compilation)
Description: Los Angeles : What Books Press, 2024. | Includes index. |
 Summary: "In this collection the author parses his past, gleans details,
 and ultimately translates into poetry his interaction with the work of
 the photographer Fred McDarrah"-- Provided by publisher.
Identifiers: LCCN 2024022974 | ISBN 9798990014916 (paperback)
Subjects: LCGFT: Poetry.
Classification: LCC PS3612.I333 S56 2024 | DDC 811/.6--dc23/eng/20240521
LC record available at https://lccn.loc.gov/2024022974

Cover art: Gronk, *Untitled*, mixed media on paper, 2023
Book design by ash good, www.ashgood.com

What Books Press
363 South Topanga Canyon Boulevard
Topanga, CA 90290

WHATBOOKSPRESS.COM

In memory of Mira Rostova and Gerald Lucas

CONTENTS

A BLOODY MONDRIAN IN THE BODY

An overview of Fifth Avenue:
an artery,
a spine.

The streets,
the nerve center
that tutored,
fueled my steps
as I marched among
the crowd
cutting through the night,
through my youth,
not knowing
I was taking notes.

AUTHOR'S NOTE

Anarchy, Protest & Rebellion, a photographic memoir from the '60s, assembled by Fred W. McDarrah, was my inspiration. I used each photo as a prompt. Some might call these ekphrastic poems. I don't. I would simply look at the photo and write. (and re-write). Details of each of these remarkable photos are in the index on page 73.

A REQUEST

Tennessee Williams looks to his left;
our eyes shift to the right.
The gaze of a skeptic.
Is he glancing at Ruth Stephen or beyond?
His tie swerves. Uneven creases on his forehead,
his left cheek in shadow.
It's the side of the cheek
I kissed…oh, no,
it was the left side of the neck.
When I told him I acted in his plays,
he asked, "Where, in class?"
I said *yes* and then Tennessee
asked, "Why the hair?" My friend Wally
explained: "Paul is in the play *Lenny*."
Tennessee turned his head slightly,
said, "Kiss me,"
pointing to the spot;
I aimed my lips
for Laura,
for Tom,
for Blanche…her wounds,
for Amanda;
I planted the kiss for Stanley,
for Brick and that click
he welcomed when he drank.
I kissed him for the Bronx I deserted
but like St. Louis for Tom
we were both drawn back.
I kissed him because he asked me.
I kissed him for a play
he hadn't written yet.

EMPTY

The caskets in a line,
ten white ones,
the same color
as the house
in the background
sitting with its arms
spread and you can't
blame the White House.
Oh, I guess you can
but you can't blame
Robert Swift in the first casket,
Robert, who tried to show
off in high school,
dribbling between
his legs, a sure way not to make the team.
Finally, he wears a uniform;
he hasn't started to decay.
In the second box is
Richard Finke, who brought
the tallest sugar cane to class;
he carried it back from Cuba
when Cuba was a friend.
In the next is Nicky Pizzano,
who interceded
when I was being pummeled
by the school maniac.
His raspy
voice floats
out of the coffin,
and again repeats
my name with alarm.

THEN IT BECAME A SZECHUAN CAFÉ

There's a line of Hasidic men with fur-felt hats
with no date at the bottom of the photo;
they've remained in the same garb
for centuries, the same unbending
beliefs and the mystery encased
in the Torah – the mystery
of the mystery in the mystery.
They could argue among themselves
and God, hats in place and payos growing.
I might as well be Christian, Muslim,
Buddhist, an atheist among them,
an infidel who gobbles Gefilte fish,
lox, knaidlach, potato kugel and challah.
I'd follow them into that cafeteria
on East Broadway. I'd follow them
into Friedman's on Canal and bite
into blintzes at another table. I'd eat
kasha varnishkes with eggs and listen
to them argue forever
from across the divide.

FOUR PHOTOS OF THE
CHURCH DISCO ON P. 42

For rich hippies, out-of-work royalty,
where my girlfriend worked the coat room.
Garments were left, forgotten and retrieved
by her-for-me, like that suede dungaree jacket,
a smooth cream-colored affair
and how I fell for a blue navy turtleneck.
This girlfriend later changed her name,
became a Sufi and her guru revealed
I had killed her in a prior life, heaved a stone
at her head on an unnamed beach
and when she shared this murder,
I had no recollection, but apologized
as I had for many things in this life.
Here the females at the church on April 24, 1969
are dressed with whips and chains,
one with a bikini bottom, another, bald-headed with
a braided wig. There's one in an unassuming dress
with half-exposed breasts exposing me
to my desire and, yes, I might have asked her to dance
on April 24, 1969 in my suede jacket
and blue turtleneck while Joan
was still Joan and working the coat room.

MOTHER'S MOTHER

There's my grandmother again with her
wide jaw, sag, and always seated, a lump
of Yiddish who is friendly beyond the scare
of wrinkles and sounds. Welcome hugs
and wet kisses. But this woman has a picture
of Christ hanging on the door of the Endicott,
101 West 81st Street at Columbus Avenue, Oct 4, 1969.
No matter: the cheekbones, glasses,
the intense showdown with the camera,
an opinionated grasp of her hands holding
onto the old country with bones and veins.
She is alone in this photo far from challah
and chicken soup, but on this chair,
on this tray, she is served to us.
We lift her or kneel down and
let her smother our little bodies.

ILL-PREPARED

Two VW bugs and a '56 Olds parked.
It's where live acts went up
and when I got the call
at midnight to meet a friend,
I asked no questions and watched
a standard-beautiful blond
strip, surprising the audience
when she dropped her last garment
to reveal a full-fledged penis,
an authentic cock which disturbed
the predominately straight audience,
including me, for having ogled
tits and legs, but not prepared
to challenge those urges.
When I left, a policeman stopped me,
said he had reason to believe
I was dealing drugs, steered me into
a hallway and frisked me, lingering
on my ass, one hand on
his revolver. He roamed
my frozen 19 year-old body.
But back to the awning with a banner:
"Warhol live, the Velvet Underground Party Event."
Two guys in the doorway.
Everything wet from rain.

HOLLOWS

Where the deprived are deprived.
One, naked, sits on a chair with his legs
crossed. Another finds peace
in sleep in the corner.
A boy contorts in a yoga-like
pose. It's the destination
for the forgotten, for those who can't
dress themselves. A girl outside
the frame screams and bites
her knees and wrists. Her name is Cindy.
She has three different voices.
All originate from the stains and grime
that cover the walls; all are ominous.
Now she rocks back and forth
to the lullabies she never heard.
She finds comfort in her sway.
The residents in a lower photo
lie down with a camera above
to shock us into legal action.
The bones of these infants could have been
shipped from Buchenwald.
The pencil-thin legs reveal starvation.
You can see below the skin,
into the hollows. Stop and weep
a few moments and then return.
Return to the boy's face—
who looks like I did as a boy.

IT IS SAID THAT DEPRESSION IS ANGER TURNED INWARD

It's gotten worse, Michael. We're 43rd
in infant mortality. We're a third world
country. Your depression, what you wrote
so openly of, opened the gates
to honesty. Turn to your left
and stroll down Thompson Street, Michael.
There's a restaurant between
Bleeker and Third on the east side
with a bocce court inside.
You can eat veal scallopini
with a glass of house wine while you watch
the action. It might relieve the blues—
a ball speeding along, smashing others.
You can hear the clacks, the collisions
as players knock their opponent's balls
far from the pallina, and roll theirs closer.
Those little triumphs can lift the spirit,
and for a moment we might forget
the whimpers of infants.
But here you are, Michael, youngish, tie
slanted to one side, the knot deformed,
and your mouth angled in the same direction.
Both eyes toward the camera but one
half-closed, to blur the starkness.
A pleasant face,
standing in your overcoat in front
of the peeling doorway.

IT TILTED THE ORBIT OF THIS PLANET

The tops
of heads, frame to frame,
roll and sweep along:
the festival known as Woodstock, August 1969,
as studied as the invasion of Normandy.
I'm not the mustached guy strolling towards
the lens
or the infant getting his diaper changed
or a boy in a white T-shirt
with his back to us.
No, I am outside the frame in a VW Bug
with four others, voting whether
to continue through mud
with two miles to go
to this photograph.
It's one to one.
Lightning.
Rain.
Everything soggy.
Crosby, Stills, Nash, and Janis
share umbrellas.
The Who erupt in
a downpour.
Hendrix will destroy
his guitar. The folk singer
with the lisp is lost
in his notes, the one
who had the crush on what's-her-name?
The tally is two to two. I break
the tie to make
the U-turn.

I didn't know I'd
see the film.
I didn't know
I'd see this photo.
I didn't know.
It was 1969.
I knew everything.

A CULTURAL DIVIDE ACROSS AMERICA

I would sleep
in the afternoon
and wake
when those two adults slept.

Or I'd sit in the backseat
of their car,
not say a word,
not answer questions,
not mention the weather.

Streets passing:
an oak tree,
tenements,
pedestrians at a crosswalk.

I'd bathe in the silence
of the years between us.

I planned my suicide for 28,
not a detailed one…a sketch.

But I was in a Broadway show
so I put it on hold.

AS IF

Sal Mineo with a cigarette hanging
from his mouth, in an unbuttoned
denim shirt— yes, the boy who died
in James Dean's arms,
the boy who followed
him and Natalie Wood around,
who stood for every kid
who longed for cool parents.
Sal said, "Hi, Paul."
Sal Mineo, said, "Hi Paul."
"Hi Paul" shot out of celluloid,
as if we were both in *Rebel Without a Cause.*
Sal, backstage, said, "Hi, Paul,"
as if we were friends as
I left my dressing room
and although
he was killed in the film, he seemed
to be resurrected to greet me.
Soon the police would arrive
at the Morosco Theatre
on 45th Street just west of Broadway.
Surely they would shoot my brother Sal
again and then hopefully shoot me.

BETWEEN ACTS

He committed suicide but for now
wears a black polo as he prepares
an espresso. It's March 19, 1966.
When I was seventeen I drank three
at midnight, then swung from the chandelier
in his Café Cino, the size of a living room
where I saw the play *Moon* five times.
The lead character smothered
his friend with a pillow. He didn't feel
too good about it but was convincing
and I played the part ten years later.
Andy Warhol might be standing at
the entrance in a motorcycle jacket
with his entourage. Here we are
in the clutter of photos and photos
and flowers, a lit sphere,
and Joe Cino intense as he focuses
on the whims of his espresso machine.
We're between acts as the compression
builds steam, smoke, fumes, unresolved
patterns coalesce in a burst
that chills everyone with disbelief,
then gasps, but for now: *Joe, please*
give me two shots with a twist.
Pour it into this lonely mug.

SUBTERRANEAN

The pavilions, rides and global
contributions attracted
little of my attention

and I am sorry to say
nor did man's flight to the moon.
The concoction of this World's Fair

where the Unisphere rules—
and still does—
in Flushing Meadows, Queens

where for a few months
countries got along,
borders porous;

water fountains lit
in the background,
with elevated towers

lifting Robert Moses and crowds
to heights
left me in a crawl.

Tangled, earthbound,
with a singular periscope,
I tracked nothing

but myself.
This photo cuts
off the sign,

"Carribean Pavilion."
We puzzle over ribbean avilion.
Names, severed.

Meaning lost.
I rarely wandered
above 14th street.

UNFILTERED

The smoke hangs over the street
drifting north over Times Square
where the Camel sign reigns
and the man exhales and exhales

the unfiltered cigarette. My father
burned through three packs a day.
Butts would float on top of the urine
in the toilet, evidence that he could piss

and smoke simultaneously. I remember
the unending stream. Here the billboard looms
over Hector's, a cafeteria, one of many
scattered across Manhattan.

Feb 21, 1964, a year my father was alive.
It must have been late when this photo was shot,
given the lack of traffic. Two dim headlights
in the foreground. Shadows head downtown.

A record store lights up the lower
right corner, but it's that rhythmic
smoke, the steady beat of the lungs,
that uninterrupted puff of a man in a cap,

a postman, a policeman, Everyman who sends
a plume into the air like a wish, a halo
reimagined over and over. It just killed
everyone who saw it, even my father.

HOME FRONT

All the evidence
is in this photo:
Abbie on the left,
Anita, the right
and a cocked baton attached
to a policeman between.
The announcement
came over WBAI
at midnight: "Bring bells,
flowers, beads,
music, radios,
pillows, eats,
love and peace."
I just brought myself,
took the Lexington Avenue line
at Union Square
to Grand Central
where two cops
carried me off.
Cradled me.
I didn't cry, call them
pig or brother.
My voice was pre-nascent,
my body, something
I dragged
from demonstration
to celebration.

PUPPETS

The three-storied puppets,
hands bigger than heads and gowns
to the ground, a 1962 Mercury
parked to the side
with slanted front lights
watching it all.
The Bread and Puppet Theater
parades down MacDougal Street.
VIETNAM is bold and hand printed
on the chest of a puppet,
blind as the war,
and inside the puppets
are puppeteers who follow
instructions from the creator, Peter Shulman,
rather than a drill sergeant.
A musician with a papier mâché-skeleton face,
meant to spook us into
sanity, beats a marching drum.
A fire hydrant in the lower right hand
corner listens to the pleas for peace.
I want to mention what happens
under the drapes of these oversized
puppets, how we both maneuver
them and fondle one another,
stroke each other's genitals
while we protest
while our classmates from high school
disappear.

FOR SALE

The collection of knives, Swiss Army,
Ka-Bar, Karambit and others,
rows of smooth steel, the glint
among the allure of army jackets,
boots, backpacks, vertical sleeping bags
lynched from the ceiling, camouflaged.
They'd seen it all. Now, looking out
Kaufmann's window they dream
a civilian life. *Take me into
the peaceful world,* they plead,
*into the damp street, perhaps to a movie,
perhaps an art gallery.*

NONJUDGMENTAL

There's the backside of a sculpture:
two figures intimately
on top of one another.
A sculpture of a man
with arms crossed
watches a few feet away
while three actual humans
look at the lens—and we too
are voyeurs. The sculptures, white
with wrinkles that papier-mâché
or clay often create.
Like certain works of art, it gets
better the more we examine it,
even the embarrassment
of the guy in a bow tie who denies
the aesthetics of copulation:
Perhaps the figure lying down is dead,
Perhaps the one on top is also dead.
Perhaps they are ghosts or soiled angels.
On Sheridan Square in the West Village
a George Segal sculpture of
a man relaxes on a bench;
I would sit beside this friend
and recite my sordid stories.
His unflinching countenance
listening, and listening.

FIFTY-THIRD BETWEEN
FIFTH AND MADISON

There's Frank O'Hara in the same
posture as the sculpture,
hands, legs and fingers in perfect sync,
as spontaneous
as his verse.
I remember this spot
in the Museum
when entry was free
and I would bite
into an apple
from a bowl
of Cezanne's fruit arrangement,
stain my lips with color,

murder an innocent
with Bruegel,

ogle women
from multiple angles
with Picasso,

soar in oil and clouds,

as familiar
as the crannies
of an alley
where I played Ring-a-levio
as a boy
when my breath
was short

from excitement:
the make-believe
that seemed
so real.

I'd go down
into the museum basement
for a Louis Malle film
or Goddard:
steal a car
with Jean Paul Belmondo,

preserve the severed hand
in a jar of formaldehyde
— of a dear, dead friend—
set it on the shelf
next to a few oblivious books
in what's the name of that Max Ophuls film?
No it wasn't Ophuls.
Give me a minute…

—Jean Vigo, *L'Atalante.*

LINES

There's Mickey, owner
of "The Annex," a dangerous walk
from Houston Street where I lived.
The backless stools line up
like foot soldiers along the empty wooden bar
with the mirrored wall
reflecting whisky bottles,
and if you sat there,
your face and a glass of scotch on the rocks
would double
in the patches of light.
Sawdust on the floor.
Mickey, holding a cup,
faces the camera.
The literati, the beat,
the hip, the sheep
followed him from
saloon to saloon,
line after line. From here
to the 9th Circle, then
his Max's Kansas City on 18th
with chickpeas on the table,
ready for the crunch.
A stew of poets, painters,
musicians, actors.
Warren Finnerty and Robert Creeley
devour free chicken-wings at the bar.
And dancing to the bands upstairs—
a room to reclaim your body.
I traced his footsteps
to Saint Adrian's on Broadway

where Thursday night a blues band
would play while Marisol Escobar
leaned on the bar;
I leaned on her, but
back to Mickey's smile,
his cocaine-slender frame
invites us.

SHY

Marisol Escobar faces front center,
her arms crossed, leaning on what
appears to be a painting of a dress,
her intensity, head forward—
around her startling manikins,
puppets, colorful well-dressed nobodies—
but she the *somebody,*
with chiseled features,
who often confessed
how anxious she'd get
when asked to lecture;
She would turn her back
to the audience to speak
but here she lets us feast
on her face, the one that drew
me to her bar after bar
until she led me to her high-rise
where I massaged
her back when blood nourished
her copper skin and bones.
With eyes turned away,
she directed me.

THE MERCHANTS SHOUT FROM
THE MEDINAS

Smoke in the air settles
over the Empire State Building.
We face north on Orchard Street.
It's not Sunday because cars are parked
on both sides of the street.
This black and white photo camouflages
colorful bargains and, like any bargain,
both parties leave victorious.
Orchard Street, where my family
would stroll through family stalls
among families of jackets,
shirts and sweaters
swinging in the breeze.
We imagined our bodies
filling out those garments.
The allure of plaids, stripes,
and cheap prices. There's
a headless seersucker suit
dangling from a fire escape.
Five stories above, a clothesline hangs;
the unabashed underwear
reveal their secrets.
The sell, the haggle, the triumph
in soft cotton and supple leather.
This bazaar stretches
thousands of years back.
Four years after this photo was taken,
three blocks from here,
a gang hanged a hippy in effigy
to welcome me to the neighborhood:

bodegas, cock fights
with a whiff of sour pickles
drowning in barrels.
I'm on the hunt for a three-pack
of Fruit of the Loom briefs.
Whatever the salesman says
I'll offer a dollar less.

EAST VERSUS WEST

At the BE-IN of beads
and acid. *We are all one.*

It was confusing
with the rage

of so many years
beginning to surface

while love climbed the bark
of every trunk

and me dissolving into atoms.
The lamppost as holy

as a maple tree
with ancient Indian patterns

talking about un-self, no borders,
and chit-chat about surrender.

Everything stripped
from the word assigned to it.

Revealed.
The terror of last night could be

overcome by smashing dishes
or seen in burgundy, blue

and violet prisms
contracting and expanding. . .

VIEWS

The riders on the ferry
are in shadow while downtown is lit
except for darkness
creeping up from the street,
a shade that matches
the bodies in the foreground.
Everything stationary.
The crowd's favorite show is
Twilight Zone and they all play their parts
approaching the island.
Everyone is invited.
The boy on the left
considers leaping off.
No one would notice. Four people a day
are killed in the city.
Few make the 11 o'clock news.
I am on the lower level drinking
coffee and biting into a hot dog.
I wouldn't hear the splash.
My bicycle is with me, a Raleigh.
I will ride through the clusters
of buildings to Union Square
where Klein's Department Store
sits on its throne. I will then pedal
to 134 East 17th Street,
carry my bike up five flights,
open the window in my apartment
that looks out at another apartment
and hope that the girl, imprisoned
by a fast-talking dilettante,
will once again dash across the kitchen,
naked and in full view.

SISTER

Her belly exposed
where a peace sign
is tattooed. She signals
victory with two fingers.
Her Jewish-afro on top
of her standing
on top of a stoop
proclaiming her view
the way she perched
on the couch
in my apartment
and I could only make love
briefly, a disappointment
to us both, but here
is her invitation again
in bell bottoms.
Was it her familiar looks?
She could have been my sister.
Was she too dogmatic for my penis?
Voluptuous creature,
I can't change it now.
On page 58, it's 1969,
a moratorium at Wall Street
but today I would kiss
your cannabis cheeks,
wrap myself around
our mutual arousals
and then we would
protest the injustices
endlessly lining up
inside and outside
the frame of this photo.

CIRCLE

A tweed coat cuts her knees and
a leather purse hangs from her shoulder.
The sign says: ABORTION…
EVERY WOMAN'S CIVIL RIGHT.
A year later Celia would get one
or was it that year? And she went
alone and came back exhausted.
The gravity only touched me slightly.
Unlike Lisa, years later, though there
was only a one-in-three chance the child
was mine. I chipped in my third
with two guys I never met and
accompanied her to the clinic.
I eagerly gave more than a third
of the comfort. It's when children
were unwelcome but making them
was always a possibility.
This photo in front of Nelson Rockefeller's office
opens in front of me. I find myself taking in
the legs of a woman protesting alongside Betty.
The exposed calves, delicately angled on heels.
My breath shortens and my body shudders
slightly with the knowledge
that this is where it starts.

OVERLAP

This could be a photo
of my 15th year
all-guys birthday party.
I nailed holes
into a watermelon
for 15 candles
and blew them out to cheers.
Here gaping mouths
rejoice into the lens.
Released from the shadows.
After the beatings.
And the beatings.
A respite.
Only one is somber,
the rest triumphant.
A male couple, arms around
each other, heads touching
under the *New Wall Inn* sign.
It was 1968, the year
Mark repeatedly
invited me to *The Mineshaft*
because of the fist-fucking,
stirrups and leather underwear.
He thought my hetero promiscuity
would be in sync
but I was too threatened
to witness
an unbridled male orgy
for perhaps
the same reason
he couldn't look a vagina

in the eye, but I listened
to how those orifices
greeted a perfect evening.

"HEBREW NEW YEAR"

printed on a building
with letters the size of windows
and windows divided
into four squares. The man
selling pretzels waits for customers
in a long coat and hat.
Those youthful salted-pretzels
stack vertically
on his tilted cart,
the size of a casket.
The body of the vendor
has gone the way bodies go,
the way pretzels go—consumed.
Split by the lens,
half of a person crosses the street,
now on the island that divides traffic;
part of him heads toward
BREW PUBLISHING COMPANY.
The "HE" before "BREW,"
swallowed by the elements.
From the photo I can't tell if
the Williamsburg Bridge
is to the left or right and
which way Ratner's might be
with the bakery as you enter:
hamentaschen in rows,
black and white cookies not
far behind the piles of rugelach.
Walk further to the service
section where waiters are waiters
with no visible hobbies.

I'm seated at a table with
my mother. She's speaking
Yiddish to the waiter.
I suddenly understand
every word. She orders
blueberry blintzes
with sour cream,
tells me she used to scrub
the floors and change sheets
in Aunt Jenny's cathouse
on Bleeker Street.
The Jenny who was raped
by a rabbi in Romania.
Mom says she worked in that
whorehouse when she was
a curvy 15 year old,
says "things happened," then
whistles, "When the Saints Go
Marching In."

THE SUN WAS A KISSING COUSIN IN 1959

It can't be too hot because
everyone wears shirts or skirts
as they relax on *"Tar Beach"*
where I would spread a blanket
in this kingdom of water towers,
gargoyles, fire escapes
and odor of burnt tires.
I'd climb six flights,
unhinge the latch
on the clunky metal door,
and find a spot to lie
in the sun as it caressed
my face and chest.
We were urban animals above it all.
In this photo you can't find a penthouse
on the beat up surfaces and
stone walls. Rooftops
recede in a film of clouds.
In the distance, the span
of the Manhattan Bridge, and further out
a shadow of the Brooklyn Bridge,
with the concrete of Henry Street
waiting six floors below.
I am the guy in the center of the rooftop.
A tingle runs up my legs.
As you can guess,
I also love the view
of the bridge, the slight ripples
of the East River,
not to mention the bustle
on Delancey Street,

but my thighs
sing a troubling tune
about a fling, a flight,
an urge
to leap over
the edge.

KIKE

Trying to find an entry into
the eyes that look nowhere,
the shoulder-less sport jacket,
the book he holds,
A Documentary History of the United States,
his hair, a standard cut,
the curtains, it could be any kitchen
in a Bronx tenement.
And yet his life was mine:
for a year and a half on Broadway
in the play, *Lenny*.
His ascent, descent,
humor, gravity and camaraderie.
His *nigger nigger kike wop spic,*
a riff from uncensored heaven.
One night the actor playing Lenny didn't make it
to the stage to be discovered
in a heap of a heroin overdose and
I was left to improvise.
An invisible body, limp, and the needle,
the needle, his too-soon
end to truth.
Is there another word for "truth"
that indicates his deeper one,
a lava-like core,
a combustible essence?
I forget what I said.
Here he is, withdrawn
in a reluctant photo-moment,
beaten
by the frightened.

FEAR

And how would you look
at this photo, Larry Levis?
Would you pretend
you were the boy
with his rolled-up sleeping bag,
the one you ached in,
the one you slept in alone.
I try to identify
the shops on Avenue B.
The fire escapes
decorate the chill
of autumn but where
will he open that bag tonight?
He could ask another
long-haired boy or girl
and find a space.
No doubt he will,
but don't ask me.
I didn't share that way,
though my hair
was shoulder length.
No, I was uncomfortable
in the skin
of my apartment.
I locked the door
and was an unwelcome guest
in that single room.

BREEZE

They might show up on your street,
swaying in a trance beyond the grip of self.
They catch you on any corner
and serenade and I too would
like to be enclosed in a song:
a place without all the asking
and reaching. I might shave
my head, tap a drum or shake
a cymbal; let the breeze run up my robe.
Let years roll on as we orbit,
never thinking of fame, mental institutions,
the cower of my mother. Just
the encasement, the breathing.

REPETITION

The crowd packed,
while the monument
rises in the background.
Phallic tower.
Eisenhower warned us,
as if we needed
warning. The photo
is dark but suggests
oversized bleachers
at a ballpark
where fans cheer, boo
and keep score
at America's pastime.
Below is another photo
of a child with a sign:
"END THE WAR."
The child is in his 50s today.
He has kept the sign
pristine. Every day he
cleans it before
taking it outside.

GUILT

Nine men carry the casket
where the body rests
where religion starts
or stops.
Feel the weight,
the strain.
The woman in the rear of the photo
sticks her head out
from behind a wall
and almost smiles
for the camera.
The pallbearers
carry rage…silence.
These are not prisoners.
They knew the man.
They move the casket
into my dining room,
drop it on the table.
There it remains.

GASPS

He measures it in a suit and tie
then seals it. I see a man

standing in the hole and Claes
with a ruler. He buries space

in a casket: perhaps a cluster
of memories, perhaps time itself.

In Venice, California, he created a pair
of binoculars, blown-up

at least two stories. I run across
his misplaced sockets and electric plugs;

those oversized
out-of-place objects

shake my brain like a castanet.
Remember when Sam was chided

by a guard for skating in the Cubist
section of the museum.

GONE

I was beside myself to hand a dollar bill
at the marble booth at the center of
the cafeteria and witness the Vegas-like
agility of Mary, who shuffled coins like cards,
tossed twenty cool nickels my way.
Here are photos of the gold gargoyles,
marble, glass, and the spigot with the head of a dog,
tongue hanging. Just crank the handle
above and, for five nickels, place your cup under
for coffee, then proceed as four nickels
will open a small glass door where pies
prostitute themselves. Temptation is legal
and these cream pastries, chocolate
and lemon meringue, parade behind
the see-through windows. Take your pick
in the automat where men wear hats
and eat off trays and kids like me
were off our leashes. Baked beans,
macaroni, slot machines and swinging doors.
Touch what you like for a few easy nickels,
everything within reach as we skipped
from showcase to showcase. There's
a grilled cheese sandwich. Dripping.
There's Bessie putting the third nickel
in the slot, eye level with apricot pie.
She wears a wool jacket, her hands
are still chilled, but so eager.

LA DOLCE VITA

Printed on the structure in bold letters:
SAVE THE VILLAGE, WAKE UP MAYOR.
The building is decapitated,
a smoking remnant.
The property I reside in
has been sold; I might as well
put a sign out for the mayor
though it's a different mayor
in a different city.
Remember pacing back and forth
on Bleeker Street and 6th,
trying to find Emilio's Bar,
an oasis of marinara and Bira Moretti?
But Emilio's was in heaven
and I'm wobbling through graveyards.
There I am on that cobbled street,
chatting with a woman in the lower
left corner of the photo.
She knows the sculptor, says he is arrogant,
wears a beret and has a mustache,
says he isn't an artist, just an imposter.
I drift down the block toward
The Waverly Theater, enter to savor
the recently released *La Dolce Vita*.
After, it's on to Sutter's Bakery which
will be rubble in seven years.

MARSHALL McLUHAN

The man who wrote something like:
reading a newspaper in the morning
was akin to taking a warm bath,
his lips puckered,
has bubble-bath cheeks,
a drink in his hand,
says from a tipsy point of view:
they call me a communications
specialist, but I am really a poet.
Right now I'm in a lukewarm tub.
I'll talk to the girl in the first row
after I finish this lecture,
I'll hum about rainfall
and costumes. We'll tiptoe
out of this auditorium.
and stroll across Washington Square Park
to Seventh Avenue, then downstairs
into the Lion's Head. We'll enter
in a gush, adorned in soap suds.
We'll settle in the back
where Helen will take our order.

INHALE

Three toes stick
through the torn
leather of a shoe.
The heel of the other man
finds the pavement.
The two men in hats
and weathered jackets
exchange words
and odors, glance
from a faraway territory—
their domain,
where I can never
roam. The Bowery
was an exclusive club
where members
slept, and drank Thunderbird
before the homeless
scattered the globe,
before you discovered a classmate
sleeping between parked cars.
The Bowery of cardboard boxes,
those erratic villages
populated with:
We've given up.
We're in perpetual retreat.
For a rehab program
I would drive
"the bums" to parks
to sweep and pick up trash.
One told me that booze

was clothing. It was shelter.
It was food. The only thing it wasn't
was cigarettes.

CHANGE

A play I didn't see
and it wasn't until
The Local Stigmatic
 that I witnessed
Al pace the stage,
riveted to his character,
as he weaved and spun
with an incomprehensible cockney
accent, but it didn't matter,
because the disappointments,
defiance and dilemmas
brewed below his words
as he propelled
through a labyrinth
of emotions
until the audience
was as stunned as I,
but here he stands
in a white jacket
with his hand out
as if begging
for change.

JULES FEIFFER WAS NOT MY FATHER

Smiling with glasses,
slender, and I tried to make you laugh
with lines from your play,
the name of which I forget
and I'd like to forget:
it was my third callback
and I was tight so I screamed,
"I AM NERVOUS BECAUSE JULES FEIFFER IS HERE!"
which was no lie but it didn't
endear me to you.
A disapproving ghost—
bald like my father—
milled around so I yelled
until all was clear
but the funny
had been scared off
and you, Mr. Feiffer,
went on your way.

BROTH

We're on avenue C and 6th Street,
"Knishes 15 cents." A man with a coat
to his knees grasps the handles
of his cart on a cobbled street,
gloriously irregular in its line-up of stones,
six blocks from where my grandmother
lived on 12th Street between B and C,
that tenement apartment tucked
in the 3rd floor walk-up where I'd enter
into a museum of smells
with the samovar on a top
shelf, as seductive as the casbah,
and a bathtub in the kitchen;
a bowl of chicken soup,
with an occasional eggshell
lost in broth, welcomed me.
This is the Lower East Side with fire escapes
above treetops, always above,
witnesses to the changing demographics.
Not burnt, please. Is it fresh?
Who made these? Hot but not too hot.
A kasha one, please. Yes, with mustard.

SUDDEN RISE

Rudolf Nureyev,
with his arms and legs extended,
gallantly holding Margot Fonteyn.
Was it Tchaikovsky or *Giselle* playing
when he leaped
across the stage?
A cheetah.
An earthquake.
A right cross
from heaven.
A crossover dribble
no one could anticipate.
The flight so unlike
the time he sat
in a pink convertible
on Bleeker Street in the West Village,
relaxed, slouched
as a few guys
piled in
for the ride.

STAGELIGHT

Tim greeted me at Millbrook,
his LSD farm in New York

and he stood like a waspy god
in sandals, as friendly as a senator

and he had my teenage vote.
At the Fillmore I watched him

describe playing baseball, how acid
slowed the pitch and in the stitching

of the ball he found the history
of the game, contemplated the peace

it embodied, the angles it celebrated
and he had time to reflect

on the Big Bang as he swung his bat
with perfect timing and swung his bat

in harmony with the rotation
of the planet and with his swing

creation was explained and so much more...
Mic in hand, legs nearly crossing,

Allen Ginsberg to his left,
while bombs dropped

on Cambodia, Laos, Vietnam
and darkness

in this photo except for them.

AS IF HE DROPPED ACID
A FEW HOURS BEFORE

Remembering that communal
ride of five crammed into a Chevrolet,
San Francisco to NYC, five strangers, one,
a doctor with a beard to his belly lending
legitimacy to the counterculture,
anti-war sentiment and all.
The doctor visited my flat,
made fun of me for looking
for matching socks
while he waited impatiently.
He had just come from Paul's place
(with whom he was unimpressed),
yes, the same Paul I respected and called
with my moral dilemma, whether to press
charges against a Black man who held me up—
to toss him into recidivist hell or not.
So I woke Paul at three in the morning
and he suggested I throw
the I Ching. Paul, who I later ran into
in Venice, CA, but here he is, one hand
with the victory sign, the other
giving us the finger,
but smiling
as long as I stay on the page,
smiling,
as if he had the prescience
to know this war
would eventually end
and another would begin.

AND WE RETURNED TO OUR ESPRESSOS

Allen looking as if he wants
something from me, to arrive
at a similar conclusion.
He is impatient. "Aren't I right,"
he seems to say but I don't budge.
I am sold on my convictions.
"First thought, best thought."
And there is Gregory reading
into the microphone at the
Village Theatre focusing on
what's in front of him, thickening
each word with a luscious Brooklyn
inflection and when I met him
at Café Trieste in San Francisco
he invited me to smoke a joint.
After the third inhale he asked
if I thought Allen was
a better poet than he.
I replied you're my favorite.
He repeated do you think Allen is better?
I answered: "Is an elm tree better
than a meadow? Is a deer
better than a buffalo?"
Gregory said, "Don't get cute."
And then: "It's not right
that I am poor."

FREE WINE POURS

It begins on the cobbled gutter
between parked cars
when West Broadway was *West Broadway.*
Two VW bugs
wait on opposite sides
of the street
as the hordes
overtake the block.
And who is showing--
Jasper Johns, Alex Katz, Larry Poons
or my friend Tony King?
An aesthetic hunger,
an art-mob
swarming—
an epicenter out of reach—
just out of reach.

POWER BROKER

In a dark suit and tie, holding the plans
like the Torah, balding, serious with intent.
Remember when he connived,
constructed tunnels too low
for buses so the poor
couldn't swim at Jones Beach.
Or when he hid the river from
"Riverside Drive."
I'd ask why does the East River Drive
meander as it approached
the Tri-borough Bridge:
all those political battles, payoffs
explained those out-of–the-way curves
and what about neighborhoods demolished
for the Cross-Bronx Expressway
plowing through protests
and your brother Robert,
what about your brother
dying in a tenement while
you collected tolls?

EQUALITY

I could have been in the background
shouting, "What do we want?
Peace. When do we want it? Now."
A circle of helmets
swing batons into a protestor
who breaks away, running toward
the Pentagon, a lone Indian
charging the cavalry.

A sign: NEGOTIATE WITH THE NLF.

I pretended to be crazier or saner
when called to the Draft Board,
floundered on wrong lines,
mumbled monosyllables
then broke into unmanly tears.

My anti-war therapist clinched it
with a note: *Att. Draftboard:*
 If Paul had a gun
he would shoot whomever
was nearest, regardless
of the color of their uniform."

DECEPTION

A photo of you in the lower
right hand corner, smiling,
eyes closed. You look like her,
or she you. In the elevator I had just
snorted cocaine in your apartment
with other high, high-profile
children which made our brief
conversation fluid, natural.
It leveled the playing field, you
the senator and I the stoned
unemployed actor, the boyfriend
of your daughter. There's not much
to go on in this photo...
your ice cream smile.
You just returned from Iran
and said the Shah was doing
great things for the country.

ROPE-A-DOPE

Ali in a robe, leaning
on the ropes, fatigued,
the year he refused induction,
his mouth closed.
My father would love
his closed mouth
free from braggadocio
and rhyme, as unimpressed
with Ali as he was with me.

I remember when
I said Johnson and Nixon
were the same, thinking of
the blood in Vietnam,
and my father spewed disgust.
Was it really disgust at
his father who deserted
or his mother who deserted
her sanity or me who deserted
his opinions?

I met Ali in Santa Monica when
there was peace in the east and
he was shuffling and dancing.
I leaned like him on the rope
outside the ring and he smiled
and waved me in.
I said I like it outside
then climbed over.
Ali circled. I didn't think he even
noticed my presence.

He flicked a jab and followed
it with a light hook and a cross;
I did the rope-a-dope and he
recited: *you're a good learner friend,*
but you will be out in the end
and that's all I remember.

DON'T

And the boy is a hair from touching
water in a dive as only a photo can halt.
It's when water was still water and a swim
as natural as a breath. The boy
is the same boy who would swing
on a rope tied to a maple tree, swing over
the Harlem River, a precarious arc that
I would watch far from the loop
of daredevils, within the confines
of a mother's worries: *keep a low voice*
so the neighbors won't hear,
be nice to the landlord, be aware
of father's moods, and never
never swing on a rope. At best you'll
end up as a paraplegic, not to mention
cholera after you fall into the water.

THE DOOR IS OPEN

The seat is up, welcoming us
with the stench of shit and piss.
It served tenants for a century.
Debris on the floor and a shabby cloth
covers the singular window.
It's the size of a telephone booth,
one you would resist no matter
whom you were going to call.
I had a toilet in the hall on 17th Street.
It had a padlock but only I had
the key. Occasionally a visitor
would break in and leave
blood stains or a syringe.
That stroll in the hall
forced me to buy a bathrobe
and slippers; you never
knew who you would run into.

SLOW RETURN

Covered with snow,
the swerving walkway,
semicircles and bare trees.
Stripped, weather beaten,
a people-less photo,
a eulogy to the park, minus
concerts, murders, gangs,
homeless—and the celebrations.
Allen Ginsberg lived on its border,
the 10th street side.
Kristen Linkleter, a voice teacher,
walked on my back in her ground floor
apartment on the Avenue B side.
We weren't intimate, the park and I,
until I collapsed on its bench,
coming down
from LSD.
It was then it held me in its bosom,
rocked me between A and B,
softly chanting: *You belong.*
Sit as long as you like---
until the trees are trees
the leaves, leaves,
and people, just people--
until everything
settles back
into its name.

INDEX TO PHOTOS

IT TILTED THE ORBIT OF THIS PLANET *Photo, p. 329*
In "three days of peace and music," over thirty bands entertained from sunup until sundown, August 16, 1969.

A CULTURAL DIVIDE ACROSS AMERICA *Photo, p. 64*
Sign on a window in the *East Village Other* newspaper, Avenue. B and Ninth Street, November 12, 1967: "Runaways if you want to return home but would Like someone to smooth the way call Evo (228-8640). We have a volunteer attorney who will communicate with your family."

AS IF *Photo, p. 252*
Sal Mineo at a play rehearsal, August 21, 1969.

BETWEEN ACTS *Photo, p. 290*
Joe Cino ran the off-broadway Café Cino at 31 Cornelia Street until his place burned to the ground.

SUBTERRANEAN *Photo, p. 217*
Unisphere sculpture by Gilmore D. Clarke was the centerpiece of the New York World's Fair, 1964-65.

UNFILTERED *Photo, p. 193*
The Great White Way looking north, February 21, 1964.

HOME FRONT *Photo, p. 124*
Cops chase Anita and Abbie Hoffman at Grand Central Terminal, 42nd Street and Park Avenue, anti-war protest, March 22, 1968.

PUPPETS *Photo, p. 17*
The Bread & Puppet Theatre in the first Vietnam protest, Washington Square, March 15, 1965.

FOR SALE *Photo, p. 338*
Kaufmann's Army Navy Store at Greenwich and Cortland, November 13, 1963.

NONJUDGMENTAL *Photo, p. 107*
Sidney Carroll and Conrad Janis with a George Segal sculpture at the Sidney Janis Gallery, 15 East 57th Street, September 23, 1966.

FIFTY-THIRD BETWEEN FIFTH AND MADISON *Photo, p. 108*
Curator Frank O'Hara in the Museum of Modern Art garden, January 20, 1960, with Auguste Rodin's "St. John the Baptist, Preaching."

LINES *Photo, p. 69*
Mickey Ruskin, later owner of Max's Kansas City, in his tavern, "The Annex," on Avenue B, October 1, 1964. The saloon featured barrels of peanuts.

SHY *Photo, p. 275*
Marisol Escobar, April 14, 1966.

THE MERCHANTS SHOUT FROM THE MEDINAS *Photo, p. 149*
Tenements along Orchard Street, December 2, 1963.

EAST VERSUS WEST *Photo, p. 100*
A crown of daisies, Central Park, April 14, 1968.

VIEWS *Photo, p. 22*
New York City skyline before the World Trade Center, September 10, 1966, viewed from the Statin Island Ferry.

SISTER *Photo, p. 58*
October 15, 1969 moratorium, Wall Street.

CIRCLE *Photo p. 326*
Betty Friedan holds a sign on West 54th Street on March 21, 1969.

OVERLAP *Photo, p. 116*
A weekend of Stonewall Inn riots June 2, 1969.

"HEBREW NEW YEAR" *Photo, p. 283*
Pretzel vendor, Allen Street at Delancey, December 2, 1963.

THE SUN WAS A KISSING COUSIN IN 1959 *Photo, p. 151*
A tenement rooftop for cool summer breezes and views of the bridges from Henry Street, August 30, 1959.

KIKE *Photo, p. 248*
Lenny Bruce in the Marlton Hotel, 5 West Eighth Street, November 5, 1964.

FEAR *Photo, p. 6*
A runaway on Avenue B in East village, November 12, 1967.

BREEZE *Photo p. 118*
Finger cymbals on Fifth Avenue by Hare Krishna, August 2, 1969.

REPETITION: *Photos, p. 52*
The peace movement in Washington, November 15, 1969.

GUILT: *Photo p. 16*
Funeral, Sept. 25,1971, for victim of Attica State Prison riots where thirty-nine inmates died in the uprising.

GASPS *Photo, p. 237*
Claes Oldenburg digging a coffin-sized "Hole" measured to exact specification, then closing it up, in Central Park, October 1, 1967, behind the Metropolitan Museum near the Egyptian obelisk.

GONE *Photos, pp.174–175*
The last Horn & Hardart, West 57th St., June 19, 1960.

LA DOLCE VITA *Photo, p. 20*
A landmark sculptor's studio at Tenth Street and Greenwich Avenue being demolished for new apartment building, May 16, 1960.

MARSHALL McLUHAN BATHING *Photo, p. 156*
Communications specialist Marshall McLuhan gives a lecture, May 9, 1967.

INHALE *Photo, pp. 176–177*
Two men, a common bond, the Bowery May 20, 1966.

CHANGE *Photo, p. 286*
In his first major role, Al Pacino was featured in Israel Horowitz's *The Indian wants the Bronx* at the Astor Place Theatre, February 27, 1968.

JULES FEIFFER WAS NOT MY FATHER *Photo, p. 309*
Cartoonist and writer Jules Feiffer, October 8, 1963.

BROTH *Photo, p. 63*
Hot knishes all day long at Avenue C, November 7, 1964.

SUDDEN RISE *Photo, p. 181*
The Royal Ballet, Margot Fonteyn and Rudolf Nureyev, at the Metropolitan Opera House, April 29, 1965.

STAGELIGHT *Photo, p. 90*
Tim Leary sits with Allen Ginsberg and Richard Alpert at the Fillmore East, 1966—the event was a "psychedelic, religious celebration."

AS IF HE DROPPED ACID A FEW HOURS BEFORE *Photo, p. 25*
Paul Krassner, in Daily Ramparts office, makes the victory sign at Yippie headquarters, Chicago, August 29, 1968.

AND WE RETURNED TO OUR ESPRESSOS *Photos, p. 6*
Top: Allen Ginsberg in front of Judson Memorial Church, March 29, 1964. *Bottom:* Gregory Corso in a marathon reading for Andre Voznesensky at The Village Theatre, May 18, 1967.

FREE WINE POURS *Photo, p. 282*
Opening of 420 West Broadway as an Art Center Sept 25, 1971.

POWER BROKER *Photo p. 241*
Robert Moses, Oct 16, 1963, with plans for the N.Y. World's Fair, 1965–66.

EQUALITY *Photo, p. 265*
Federal officers beat up protestors at the Pentagon, October 21, 1967.

DECEPTION *Photo p. 269*
Jacob Javits at the Republican Convention, August 6, 1968.

ROPE-A-DOPE *Photo, p. 1*
Heavyweight Champion Muhammad Ali in the basement of Madison Square Garden, March 16, 1967.

DON'T *Photo, p. 188*
Boys swimming and rowing in the Hudson River at 59th Street, August 28, 1960.

THE DOOR IS OPEN *Photo p.147*
One toilet in the hall, 706 East 5th Street, serving four families on one floor in this tenement, February 6, 1966.

SLOW RETURN *Photo, p. 67*
Tomkins Square Park, 10th Street and Avenue A, February 13, 1964.

AFTERWORD

Some time ago I heard a friend, poet, Cecilia Wolloch read. She said, (I am paraphrasing) "I am going to read a poem written about a place. I was distracted and didn't think I noticed anything. It seemed as if I wasn't really there." She continued, "When writing the poem, I realized to my surprise I recalled many intricate details." Well, I could say the same thing regarding a decade of my life.

More often than not I was familiar with the location, the event or the people depicted in the photos, but like Cecilia I didn't think I was fully present. I crossed paths with many of the people in the photos. Some were friends. One of my closest friends, Robert David Cohen, appears in a photo at Judson Church. I was at several of the demonstrations chronicled in the book. There are photos of the "Bread and Puppet Theatre," a group born out of the protests to the Vietnam War. I performed with them at the Fillmore East. There are photos of The Living Theatre. I saw all their productions and met a few of the members. One member became a friend. There is a photo of Tennessee Williams. I had the good fortune to meet him when I was performing on Broadway. There is a one of Abbie Hoffman. I portrayed him in a play and we later became friends. My girlfiend actually did work in the coatroom at the "Church Disco." In "Hollows," I was aware of the scandal and horrible conditions at Willowbrook; I had been working with autistic children at the time. Like countless others I went to the World's Fair in Queens referred to in "Subterranean." Well on and on my connections became apparent and looking at the photos ignited the realization: I played a part in the cultural and political tapestry of that time. I was not a lead player but I participated.

In essence I felt alienated during that period in my life. I might have been confused, volatile or emotionally distant but I did take note of what was around me. Seeing these photos and writing these poems helped me to own my experience. We have all heard people say "poetry saved my life." In this case it helped me reclaim my history.

ACKNOWLEDGMENTS

Special thanks for your invaluable inspiration and help: Marjorie Becker, Jeanette Clough, Dina Hardy, Sarah Maclay, Holaday Mason, Jim Natal, Jan Wesley, Brenda Yates, Mariano Zaro & Kevin Cantwell.

The AutoEthographer: "Subterranean," "As If," "Fifty-Third Between Fifth And Madison," "East Versus West," "It Tilted the Orbit of the Planet,","Puppets," "Gone," "Broth," "Stagelight," "Rope-A-Dope."

Burningwood Literary Review: "Unfiltered"

Eunoia Revies: "The Sun Was a Kissing Cousin in 1959." "The Merchants Shout From the Medinas"

Ghost City Review: "Slow Return," "Guilt," "Hebrew New Year"

Interlitq: "A Bloody Mondrian in the Body," "Then It Became a Szechuan Café," "Breeze," "Gasps," "And We Returned to Our Espressos."

North Dakota Quarterly:"A Request," "Empty"

Parhelion Literary Magazine:"Ill-Prepared," "Mother's Mother," "Four Photos of the Church Disco," "Hollows," "Views"

Valley Voices: A Literary Review: "Lines," "Non-Judmental"

"Lines" was nominated for a Pushcart Prize.

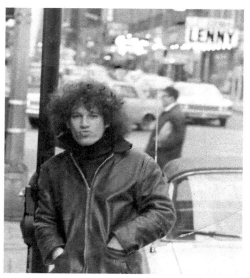

1972

PAUL LIEBER's second collection, *Interrupted by the Sea*, was also published by What Books Press. His first book, *Chemical Tendencies* (Tebot Bach), was a finalist in the MSR poetry contest. He received an honorable mention in the Allen Ginsberg Contest. Three times nominated for a Pushcart Prize, Paul produced and hosted "Why Poetry" on Pacifica radio in L.A. Paul's poems have appeared in many journals and anthologies. He taught Poetry at Loyola Marymount University and facilitated the poetry workshop at Beyond Baroque. Paul works as an actor and currently teaches acting at AMDA in Los Angeles.

WHAT BOOKS PRESS

AN IMPRINT OF

THE GLASS TABLE

COLLECTIVE

LOS ANGELES

All WHAT BOOKS feature cover art by Los Angeles painter, printmaker, muralist, and theater and performance artist GRONK. A founding member of ASCO, Gronk collaborates with the LA and Santa Fe Operas and the Kronos Quartet. His work is found in the Corcoran, Smithsonian, LACMA, and Riverside Art Museum's Cheech Marin collection.

As a small, independent press, we urge our readers to support independent booksellers. This is easily done on our website by purchasing our books from Bookshop.org.

WHATBOOKSPRESS.COM

2024

The Manuscripts
KEVIN ALLARDICE
NOVEL

Father Elegies
STELLA HAYES
POEMS

Slow Return
PAUL LIEBER
POEMS

Dreamer Paradise
DAVID QUIROZ
POEMS

How to Capture Carbon
CAMERON WALKER
STORIES

2023

God in Her Ruffled Dress
LISA B (LISA BERNSTEIN)
POEMS

Figures of Wood
MARÍA PÉREZ-TALAVERA
TRANSLATED BY PAUL FILEV
NOVEL

A Plea for Secular Gods: Elegies
BRYAN D. PRICE
POEMS

Nightfall Marginalia
SARAH MACLAY
POEMS

Romance World
TAMAR PERLA CANTWELL
STORIES

2022

No One Dies in Palmyra Ohio
HENRY ELIZABETH CHRISTOPHER
NOVEL

Us Clumsy Gods
ASH GOOD
POEMS

Skeletal Lights From Afar
FORREST ROTH
FLASH FICTION/PROSE POEMS

That Blue Trickster Time
AMY UYEMATSU
POEMS

2021

Pyre
MAUREEN ALSOP
POEMS

What Falls Away Is Always
KATHARINE HAAKE &
GAIL WRONSKY, EDITORS
ESSAYS

*The Eight Mile
Suspended Carnival*
REBECCA KUDER
NOVEL

Game
M.L. WILLIAMS
POEMS

2020

No, Don't
ELENA KARINA BYRNE
POEMS

One Strange Country
STELLA HAYES
POEMS

*Remembering Dismembrance:
A Critical Compendium*
DANIEL TAKESHI KRAUSE
NOVEL

Keeping Tahoe Blue
ANDREW TONKAVICH
STORIES

WHAT
BOOKS
PRESS

LOS ANGELES

Milton Keynes UK
Ingram Content Group UK Ltd.
UKHW040311181024
449757UK00005B/491

9 798990 014916